the **sun,**

the **sea,**

and

the **stars**

the sun, the sea, and the stars

ANCIENT WISDOM
AS A HEALING JOURNEY

IULIA BOCHIS

Clarkson Potter
New York

FOR EVERYTHING

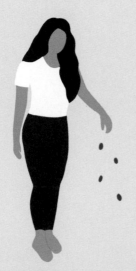

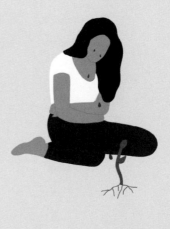

THERE IS A SEASON

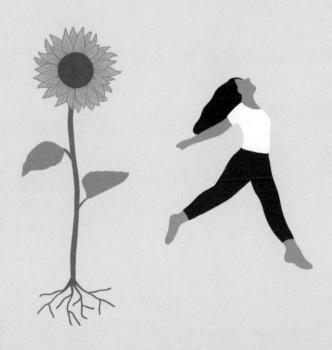

I THINK GETTING STARTED IS OFTEN THE MOST DIFFICULT PART OF ANY TASK.

BEGINNINGS RARELY MEET US ALONE. THEY OFTEN BRING ALONG FEAR, DOUBT, UNCERTAINTY, AND MANY OTHER THOUGHTS THAT DON'T MAKE THINGS ANY EASIER. THOSE WERE EVEN THE FEELINGS I HAD BEFORE STARTING THIS BOOK. YET ONCE I GOT GOING, EVERYTHING STARTED FALLING INTO PLACE, AND SOON ENOUGH I FOUND MYSELF WALKING DOWN THIS PATH FULL OF JOY AND EXCITEMENT.

WHEN I TAKE A MOMENT TO THINK ABOUT IT, I REALIZE THIS APPLIES TO ALMOST EVERYTHING I HAVE EVER ATTEMPTED IN MY LIFE. FROM LEARNING TO RIDE A BICYCLE, TO MOVING AWAY FOR UNIVERSITY AND THEN SHARING MY ART WITH THE WORLD. IF I THINK EVEN FURTHER, I REALIZE THAT SO MANY OF THE MOMENTS I HAVE LIVED THROUGH, I HAVE ALSO READ ABOUT IN BOOKS, HEARD IN SONGS OR WITNESSED IN MY FRIENDS' LIVES.

THIS BOOK WAS BORN FROM A DEEP-ROOTED FEELING THAT, WHILE WE ARE ALL DIFFERENT IN SO MANY WAYS, WE ALSO HAVE SO MUCH IN COMMON. THIS BOOK IS A STORY ABOUT THE VARIOUS MOMENTS OF SIGNIFICANCE WE FACE AS WE JOURNEY THROUGH OUR LIVES. SOME OF THESE MOMENTS ARE: CHANGE, LONELINESS, LOVE, AND HAPPINESS. HOWEVER, IN THIS STORY YOU WILL FIND THEM POSING AS: AUTUMN, WINTER, SPRING, AND SUMMER. AS MUCH AS I THINK OF THESE NAMES AS SEASONS IN THE OUTSIDE WORLD, I ALSO THINK OF THEM AS THE SEASONS OF OUR SOULS.

I WOULD LIKE YOU TO THINK OF THIS BOOK AS A MIRROR. A MIRROR THAT REFLECTS YOUR WONDERFUL INNER BEAUTY AND THE MAGIC OF THE WORLD SURROUNDING YOU. AND THE WORLD TRULY IS A MAGICAL PLACE, ISN'T IT? DURING THE DAY THE BIRDS SING THEIR SONGS AND THE SUN TRAVELS ACROSS THE SKY, ILLUMINATING EVERYTHING. IN THE DEPTHS OF DARKNESS, THE MOON AND THE STARS SHINE DOWN ON US, AND THE WAVES CRASH ENDLESSLY ALONG THE SHORES.

I HOPE THIS BOOK WILL REMIND YOU THAT THERE IS BEAUTY IN EVERYTHING, IF YOUR HEART IS OPEN TO RECEIVE IT. I ALSO HOPE THIS BOOK WILL SHOW YOU THAT, EVEN DURING THE DARKEST NIGHT, YOU ARE NEVER ALONE. WHEN IT SEEMS THAT YOU HAVE BEEN LEFT BEHIND, IN A MOMENT OF STILLNESS YOU MIGHT REALIZE THAT THE INFINITE STARS, THE RESTLESS SEA, AND THE PATIENT MOON ARE ALL TRAVELING ALONG WITH YOU.

A TRAVELER HAS AGREED TO JOURNEY WITH US THROUGHOUT THIS BOOK. THE STARTING POINT OF THEIR ADVENTURE IS SOMEWHERE IN THE MIDST OF AUTUMN, THE SEASON OF CHANGE. I HAVE FOUND CHANGE TO BE A VERY DIFFICULT TOPIC IN MY LIFE, AND I KNOW THIS TO BE THE CASE FOR MANY OTHERS. SO LET THIS SEASON BE OUR FIRST TEACHER IN TRANSFORMING, SURRENDERING, AND LETTING GO.

WITH LOVE,
IULIA

A JOURNEY

OF A

THOUSAND

MILES

STEP

SINGLE

WITH A

BEGINS

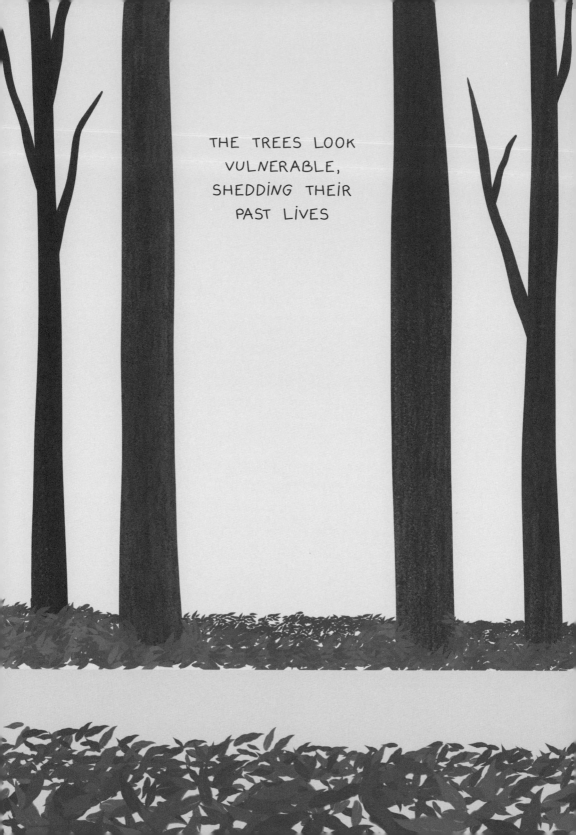

THE TREES LOOK
VULNERABLE,
SHEDDING THEIR
PAST LIVES

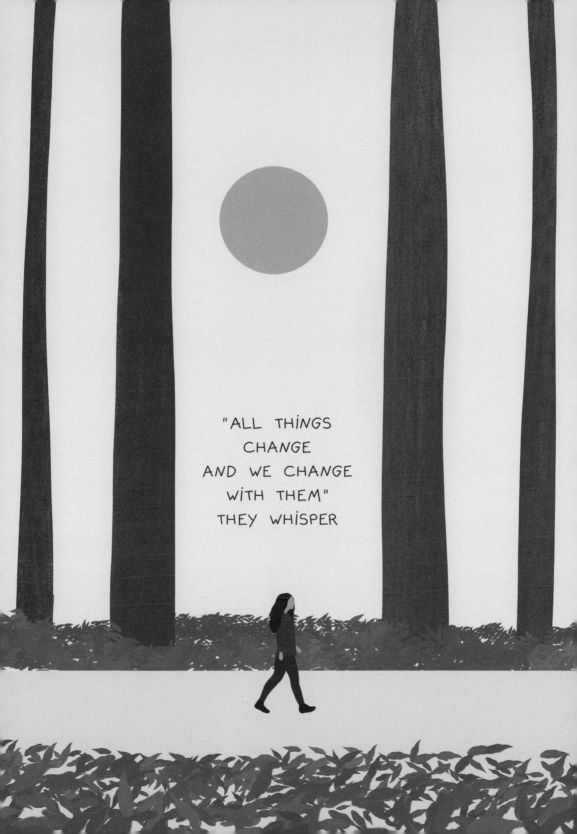

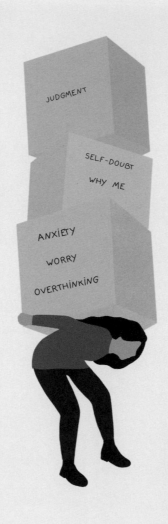

MAYBE IT'S TIME FOR A CHANGE

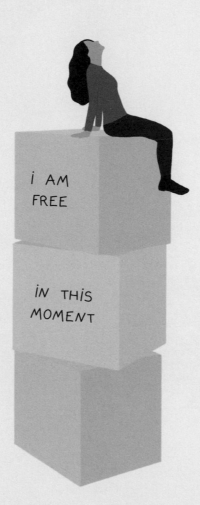

I AM
FREE

IN THIS
MOMENT

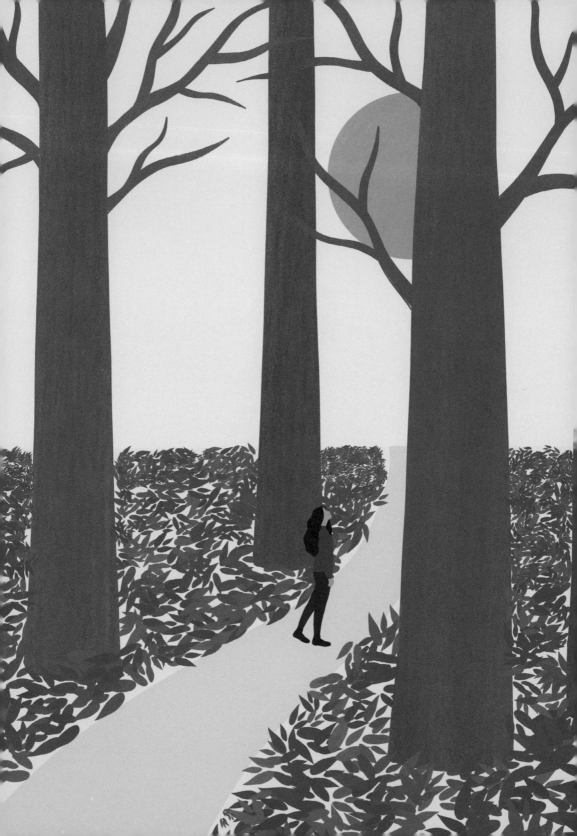

MAYBE YOU ARE
SEARCHING THE BRANCHES
FOR WHAT ONLY APPEARS
AT THE ROOTS

—RUMI

MY ROOTS LOOK DIFFERENT

BUT i, TOO, AM MY OWN HOME

WHY ARE YOU LEAVING?

THERE ARE PLACES WE ARE YET TO GO

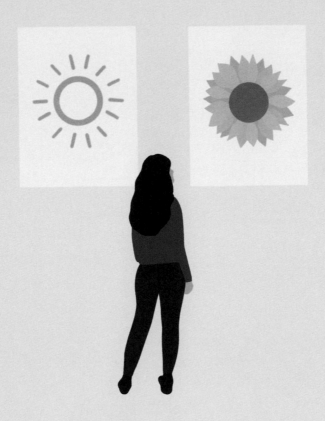

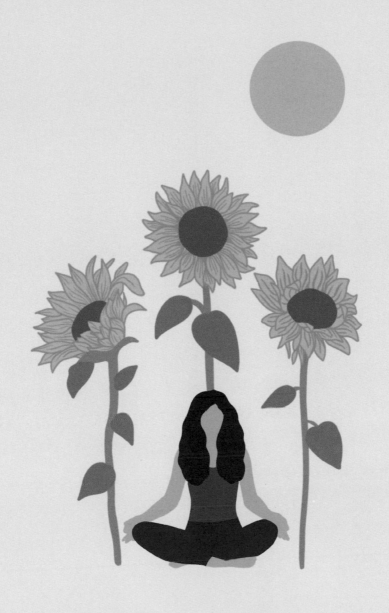

WHERE WE ALREADY BELONG

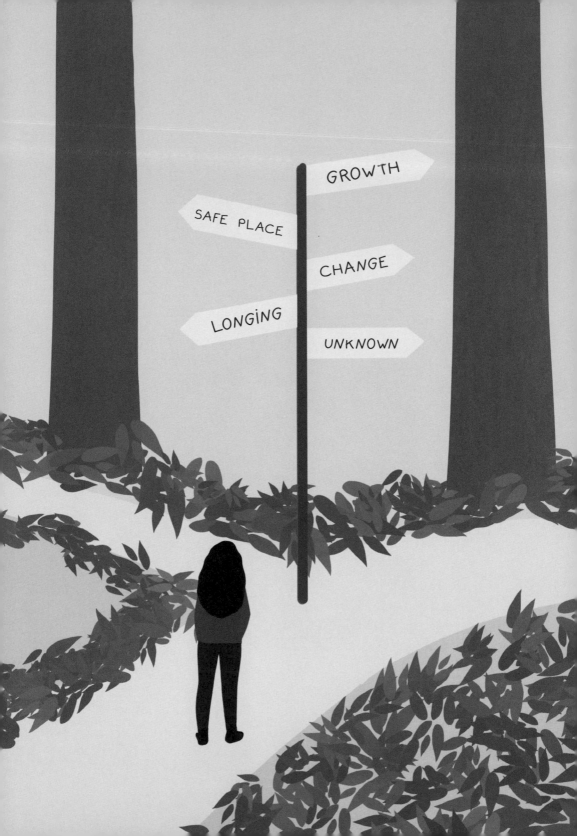

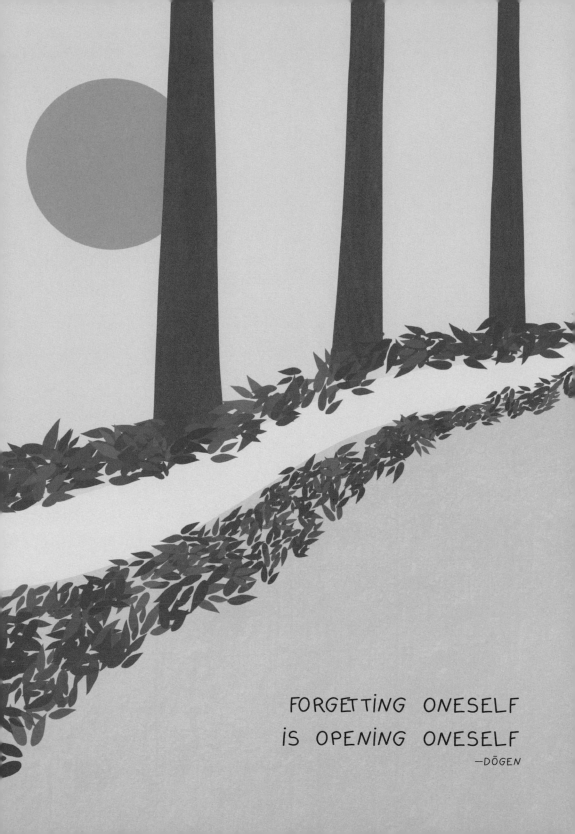

FORGETTING ONESELF
IS OPENING ONESELF
—DŌGEN

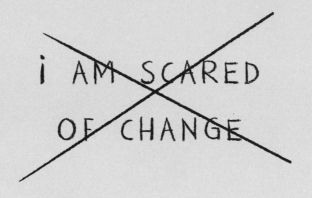

i AM SCARED
OF CHANGE

THERE ARE SO MANY PARTS OF ME

i AM TERRIFIED
OF STAYING
THE SAME

i HAVE YET TO DISCOVER

i THINK YOU SHOULD
KEEP GOING,
JUST TO SEE WHAT
HAPPENS

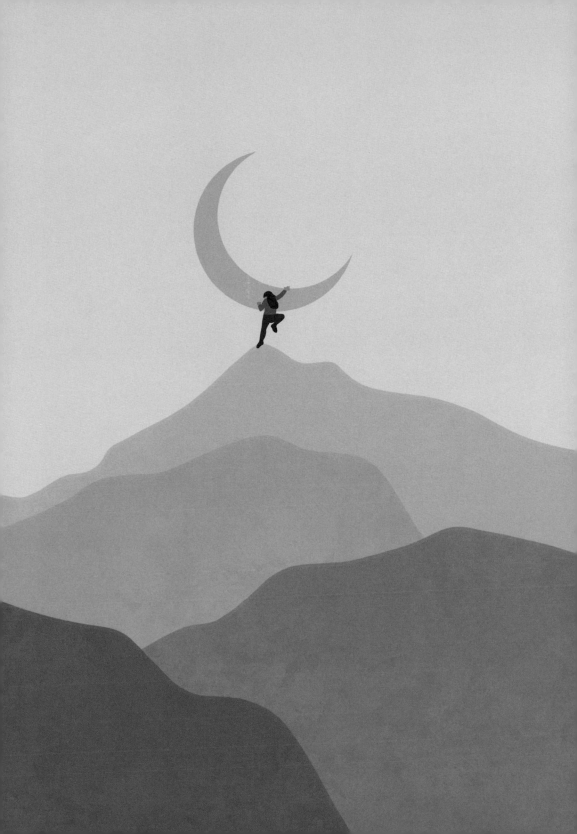

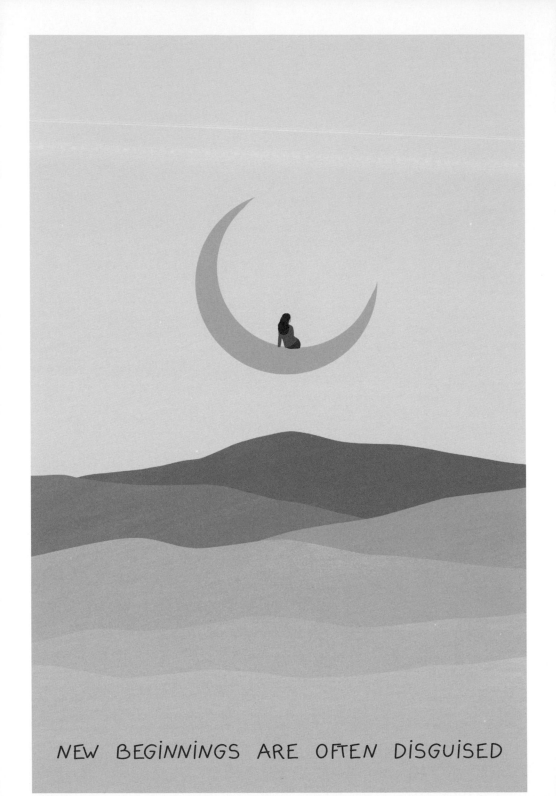

NEW BEGINNINGS ARE OFTEN DISGUISED

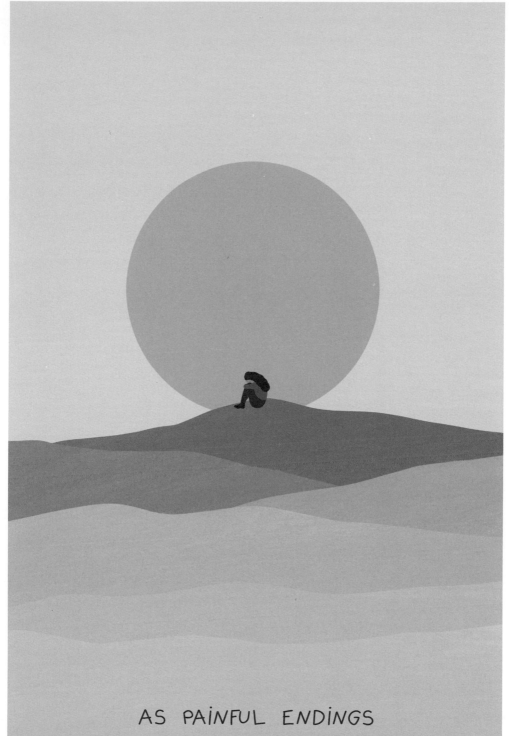

AS PAINFUL ENDINGS

—LAO TZU

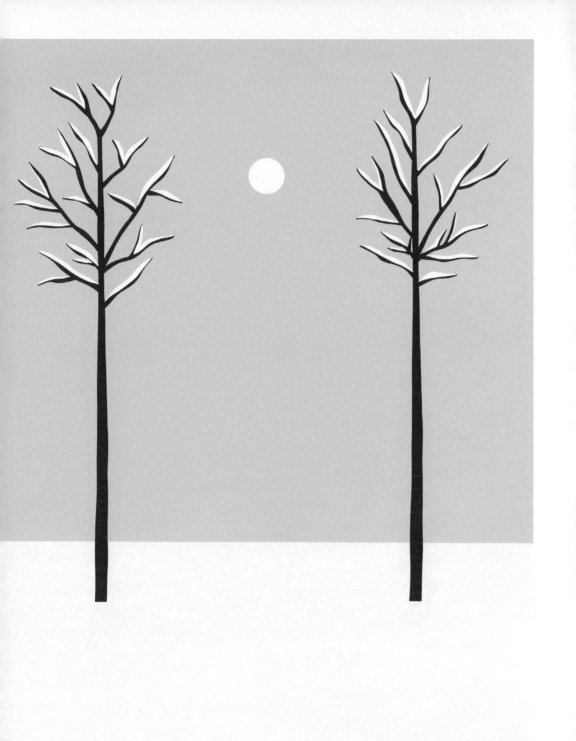

AS AUTUMN MOVES INTO WINTER, THE OUTSIDE WORLD BEGINS TO APPEAR LESS AND LESS FRIENDLY. THE NIGHTS GROW COLDER AND LONGER, AND THE DAYS SEEM TO BE SHRINKING AWAY FROM US. IN THE SAME WAY, AT CERTAIN TIMES IN OUR LIVES, WE CAN FIND DARKNESS DESCENDS UPON US. IT SEEMS LIKE THE SUN HAS SET, THE LIGHTS HAVE GONE OUT, AND THERE IS NOTHING LEFT TO SHOW US THE WAY FORWARD. WE ARE LOST.

THE NEXT PART OF OUR JOURNEY TAKES US THROUGH THIS SEASON OF TEMPORARY DARKNESS. AS COLD AND UNAPPEALING AS IT MAY SEEM AT FIRST, THE DARKNESS OF WINTER CAN BE A BEAUTIFUL TIME. A TIME TO REST, REFLECT, AND LEARN MORE ABOUT OURSELVES.

AND IF WE ARE WILLING TO WAIT JUST A LITTLE LONGER, THE MOON AND THE STARS WILL JOIN US, GUIDING THE WAY.

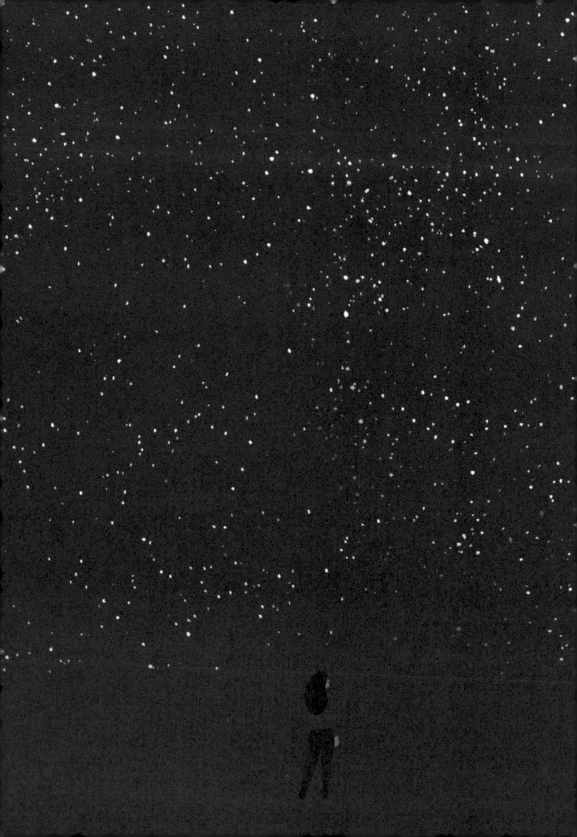

SOMETiMES,
i REALLY MiSS . . .
MYSELF

THE DARKEST NIGHT

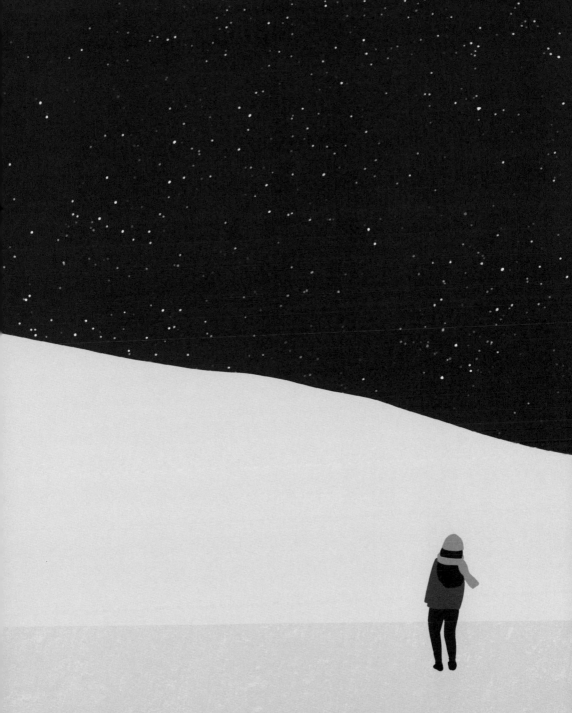

REVEALS THE BRIGHTEST STARS

WHAT YOU SEEK
IS SEEKING YOU
—RUMI

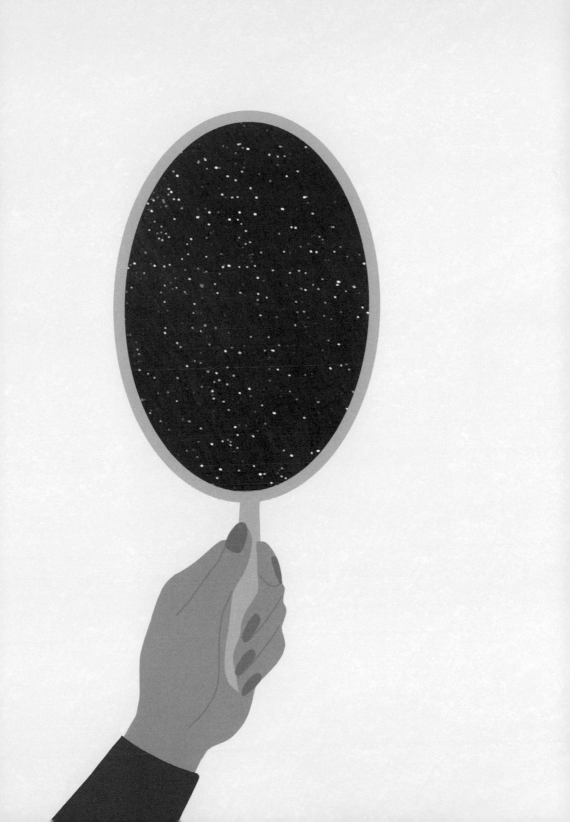

THE FURTHER I SEARCH

THE LONELIER IT GETS

SOMETIMES THE PATH LEADS YOU AWAY

FROM OTHERS AND CLOSER TO YOURSELF

THE PRICE OF SOLITUDE
IS LEARNING
WHO YOU ARE

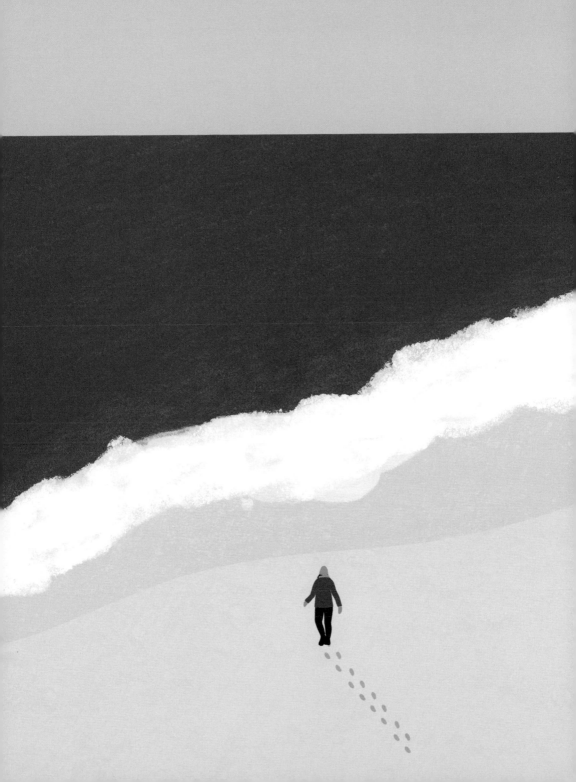

AN AWAKE HEART IS LIKE
A SKY THAT POURS LIGHT

—HAFIZ

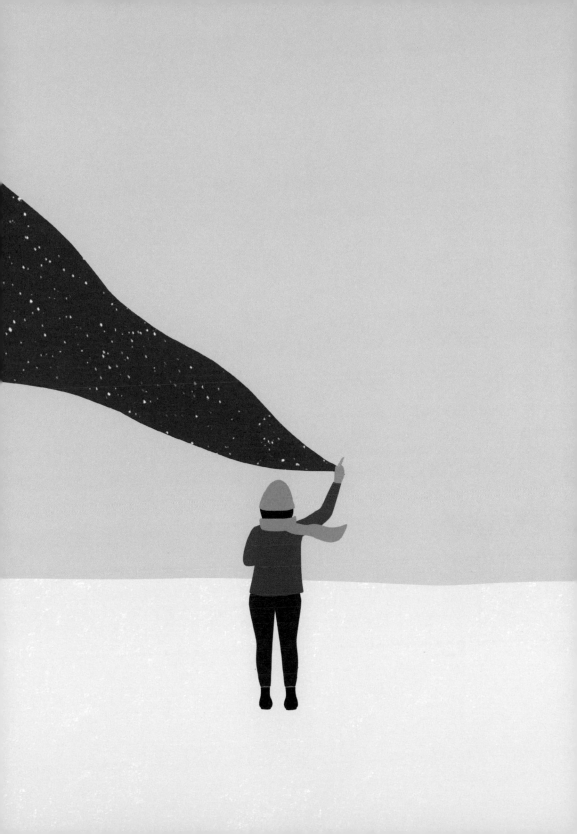

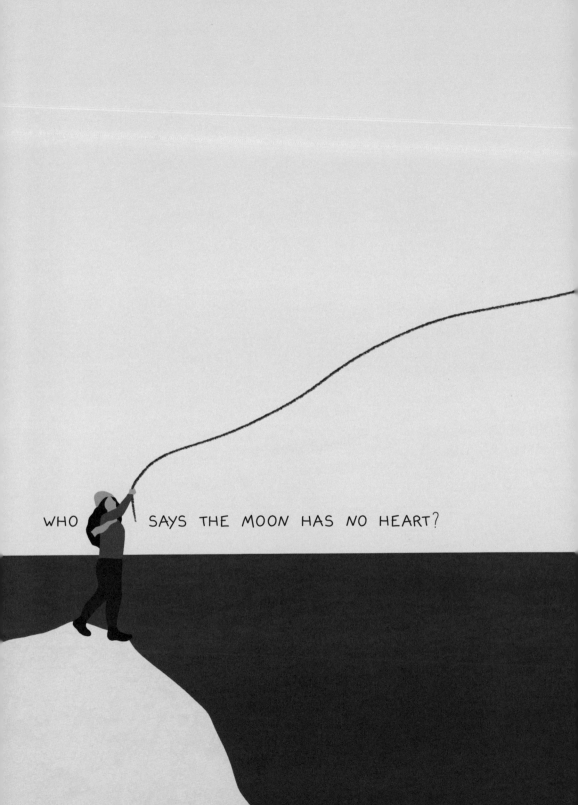

WHO SAYS THE MOON HAS NO HEART?

A THOUSAND LONG MILES IT HAS FOLLOWED ME

—BAI JUYI

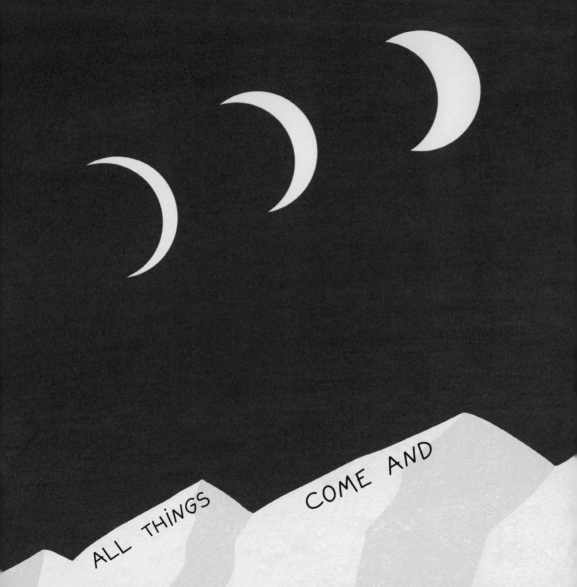

GO iN THEiR OWN TiME

PATIENCE IS NOT SITTING
AND WAITING,
PATIENCE IS FORESEEING

IT IS LOOKING AT THE THORN
AND SEEING THE ROSE,
LOOKING AT THE NIGHT
AND SEEING THE DAY

—RUMI

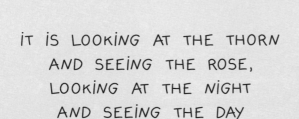

IF TIME BROUGHT US
TOGETHER,
i AM GRATEFUL

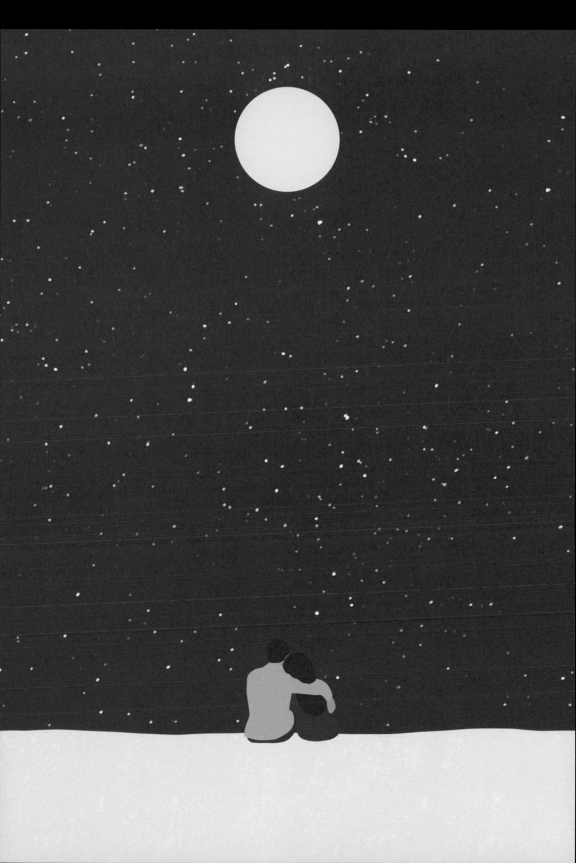

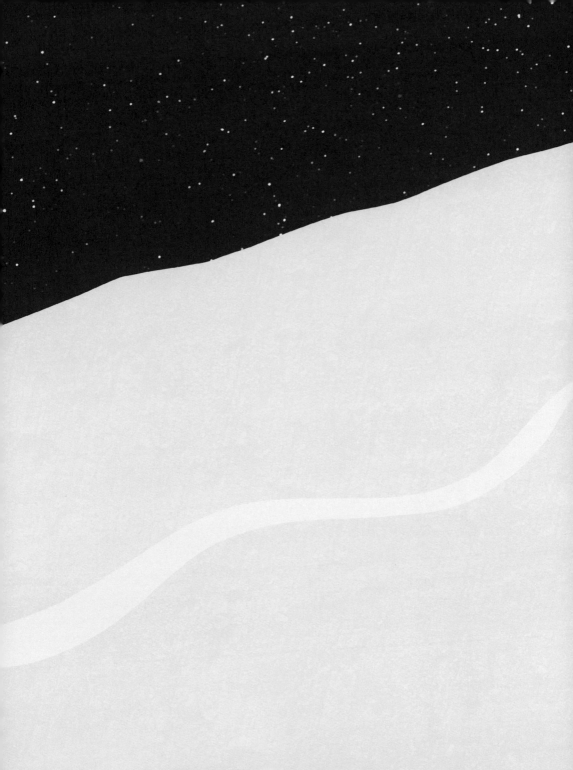

BUT NOT EVERYTHING IS MEANT TO LAST FOREVER

SOMETIMES TO BE STRONG iS TO LET GO

IT'S OK TO BE SAD AFTER MAKING THE RIGHT DECISION

WHEN i LOOK AROUND, i REALiZE

WE EACH HAVE OUR OWN STORY

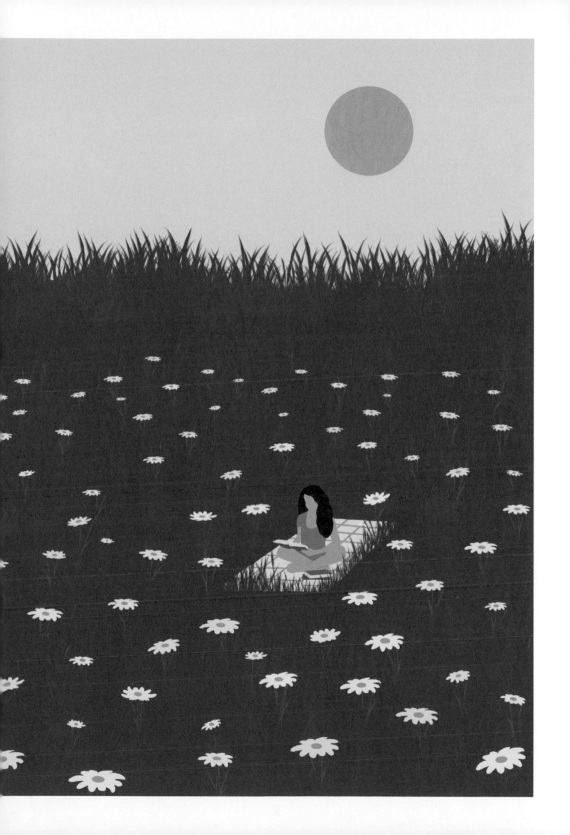

A TIME OF DARKNESS IS A TIME OF APPROACHING LIGHT. IF YOU ARE TRAVELING THROUGH THE DEPTHS, KEEP GOING, THE LIGHT IS ON ITS WAY TO MEET YOU. AS WINTER MELTS INTO SPRING, WE FIND OURSELVES EMBRACED BY THE GENTLE LIGHT OF THE SUN.

A BREATH OF SPRING IS LIKE A THOUSAND GIFTS. EVERY MOMENT IS INFUSED WITH HOPE AND LIGHT. LOOK AROUND YOU. THIS IS THE SEASON OF CELEBRATION. EVERY BLOOMING FLOWER CELEBRATES THE STRENGTH OF HAVING GONE THROUGH WINTER. AND IN MANY WAYS, i THINK ALL OF US ARE LIKE FLOWERS. WE NEED WINTER, THE DARKNESS IN WHICH WE SPEND TIME WITH OURSELVES, TENDING TO OUR ROOTS. THEN SUDDENLY, AT THE FIRST RAY OF SUNSHINE, WE TURN OUR FACES TOWARD THE LIGHT . . . AND WE BLOOM.

THIS SEASON, LET US CELEBRATE THE STRENGTH THAT BROUGHT US HERE.

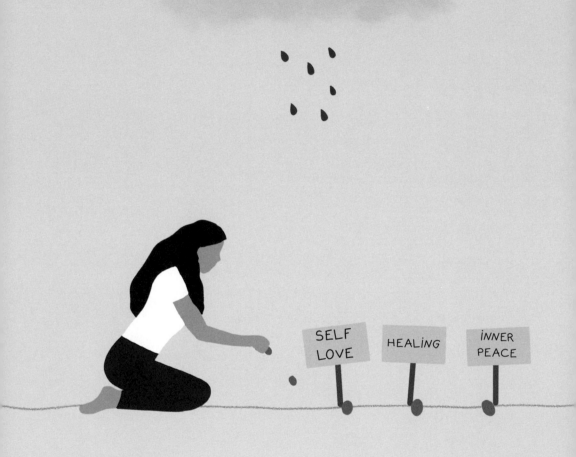

ALL THE FLOWERS OF ALL THE TOMORROWS

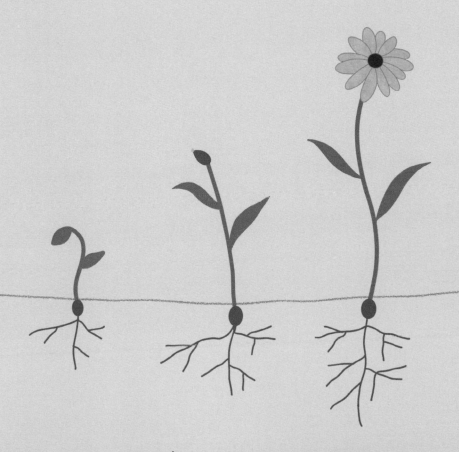

ARE IN THE SEEDS OF TODAY

—ZEN PROVERB

BE PATIENT WITH YOURSELF

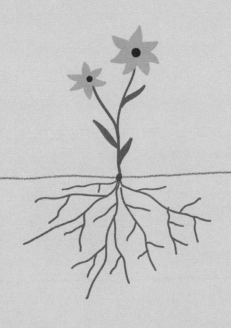

NO SEED EVER SEES THE FLOWER

—ZEN PROVERB

MOUNTAIN OF HEALING

SELF LOVE

ROAD OF

THE MAP
OF LIFE

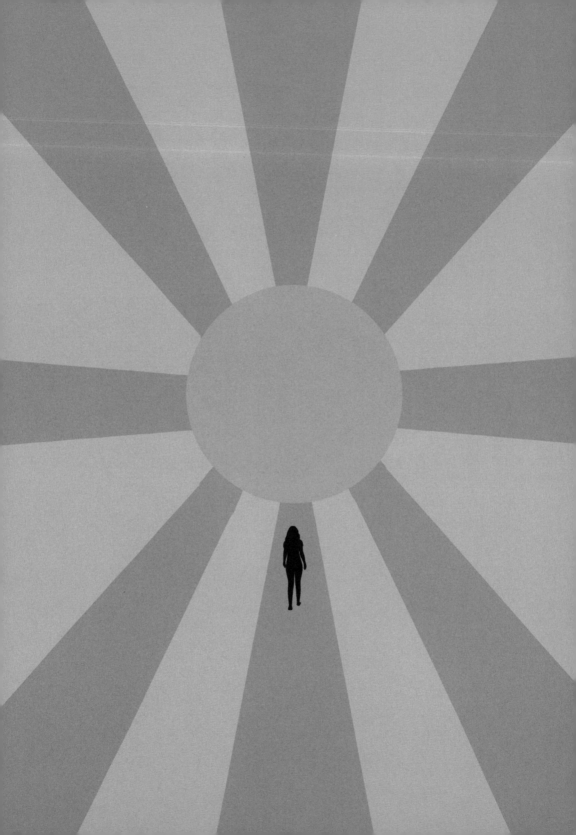

i wish that i could show
you when you are lonely
or in darkness
the astonishing light
of your own being

—HAFIZ

GROWTH DOESN'T HAPPEN OVERNIGHT

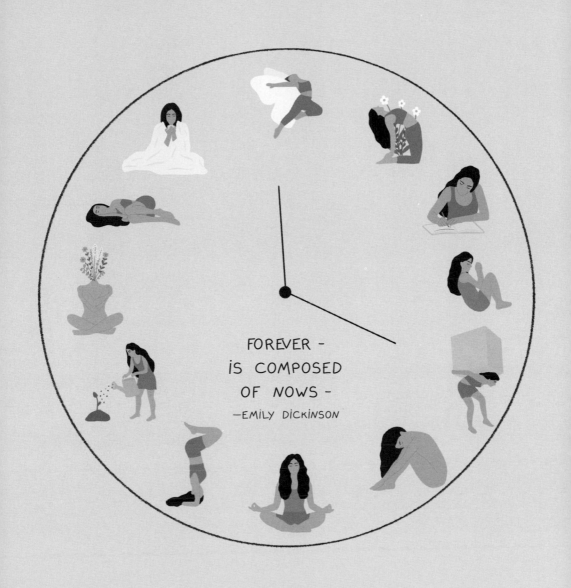

FOREVER -
IS COMPOSED
OF NOWS -
—EMILY DICKINSON

EACH MOMENT COUNTS

BEING STILL DOES NOT MEAN DON'T MOVE

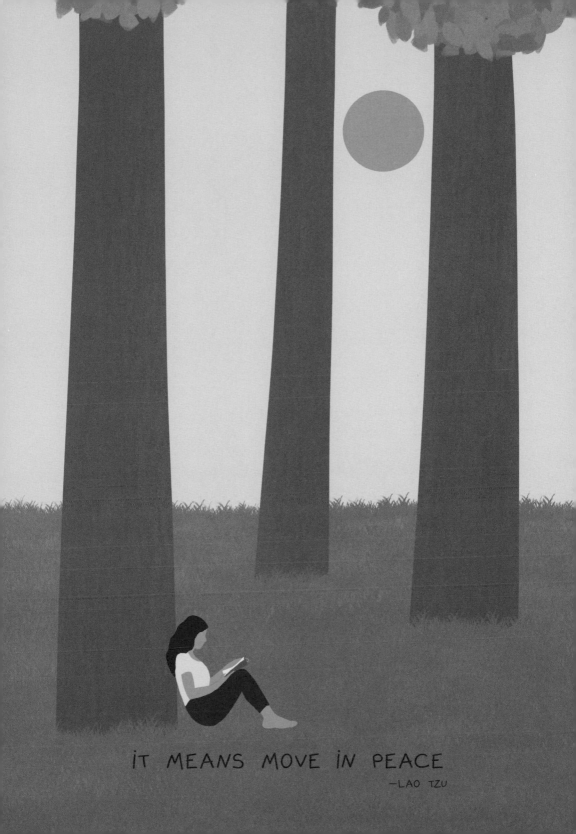

IT MEANS MOVE IN PEACE

—LAO TZU

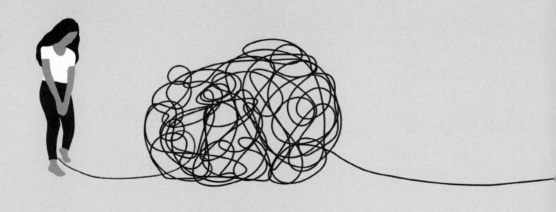

EVERY STEP OF THE JOURNEY HELPED BRING YOU HERE

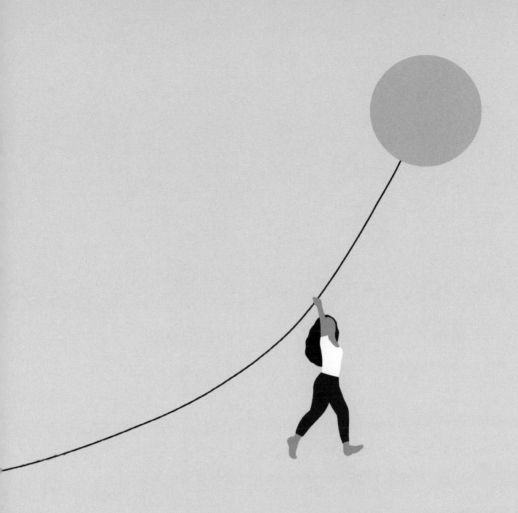

CELEBRATE YOUR STRENGTH

TODAY IS A GREAT DAY

TO BE PROUD

OF HOW FAR

YOU HAVE COME

YESTERDAY i WAS CLEVER

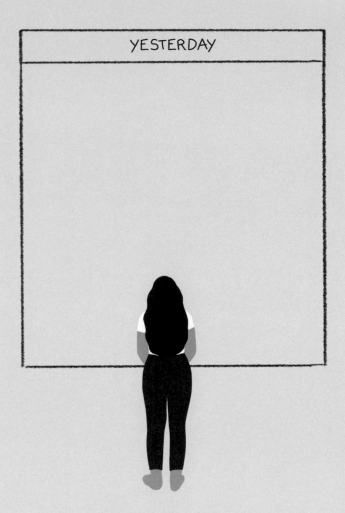

YESTERDAY

SO i WANTED TO CHANGE THE WORLD

TODAY i AM WISE

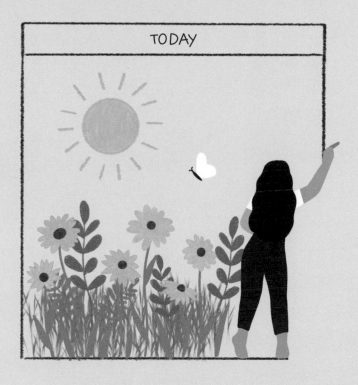

SO i AM CHANGING MYSELF

—RUMi

RELAX. THE FUTURE IS ALREADY

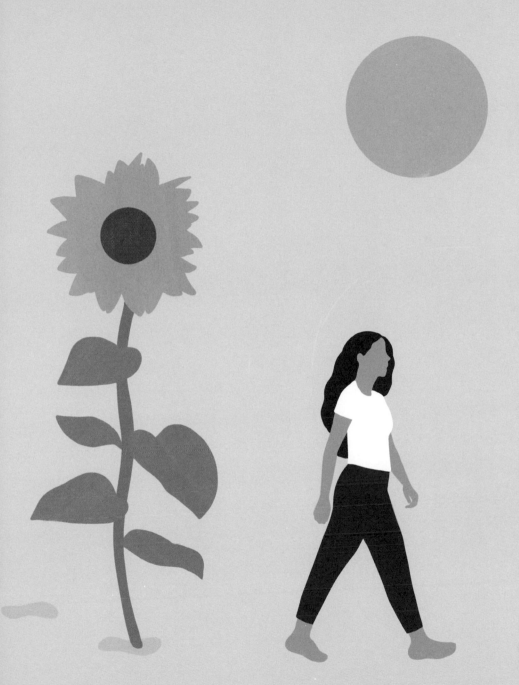

UNFOLDING FROM LONG-PLANTED SEEDS

—ZEN PROVERB

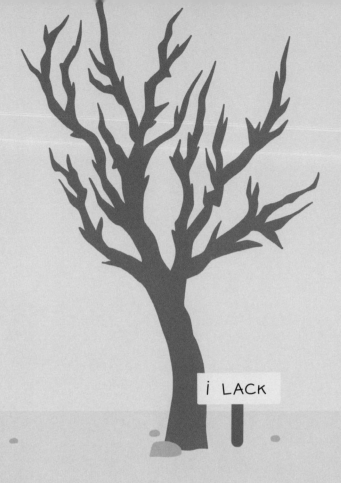

i LACK

i AM NOT ENOUGH

i FEAR

i DOUBT

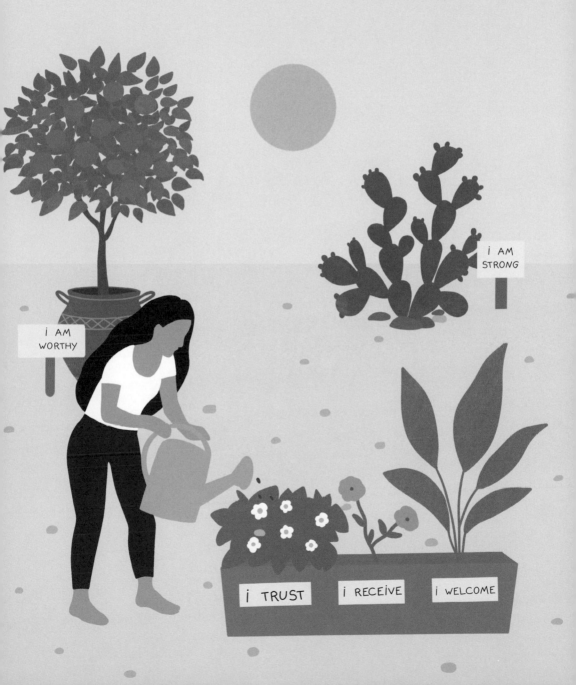

i

AM

BLOOMING

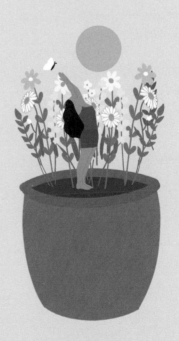

TOO

WHO I
THOUGHT
i WAS

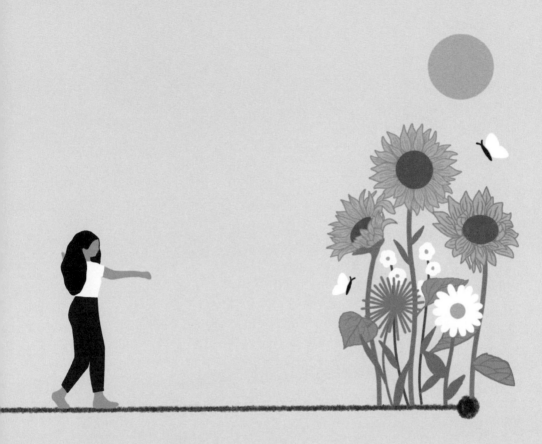

WHO i
REALLY
AM

MAY I ALWAYS REMEMBER
HOW LONG I HAVE DREAMED
OF WHERE I AM
NOW

EVER
SINCE
HAPPINESS
HEARD YOUR
NAME IT HAS
BEEN RUNNING
THROUGH THE
STREETS, TRYING
TO FIND YOU
—HAFIZ

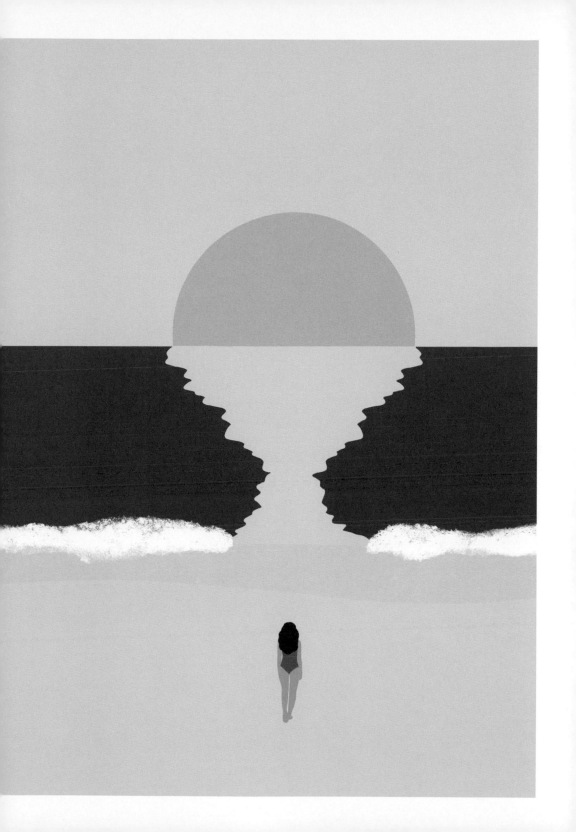

THIS JOURNEY HAS TAKEN US THROUGH THE UNPREDICTABLE WINDS OF CHANGE, THE UNCERTAIN TIMES OF DARKNESS, AND THE HEALING BREATH OF SPRING. OUR LAST STEPS BRING US NOW TO THE EDGE OF THE VISIBLE WORLD. IT IS AN ENDLESS SEASHORE, FILLED WITH LIGHT AND PEACE.

I BELIEVE INSIDE OUR HEARTS IT CAN ALWAYS BE SUMMER. THE FARTHER WE TRAVEL, THE MORE WE REALIZE WE ALWAYS HAVE OURSELVES. AND THE LONGER WE ARE WITH OURSELVES, THE MORE WE UNDERSTAND THAT IN OUR INNER WORLD, WE CAN ALWAYS HAVE SUNSHINE IF WE CHOOSE.

LET THE LIGHT IN.

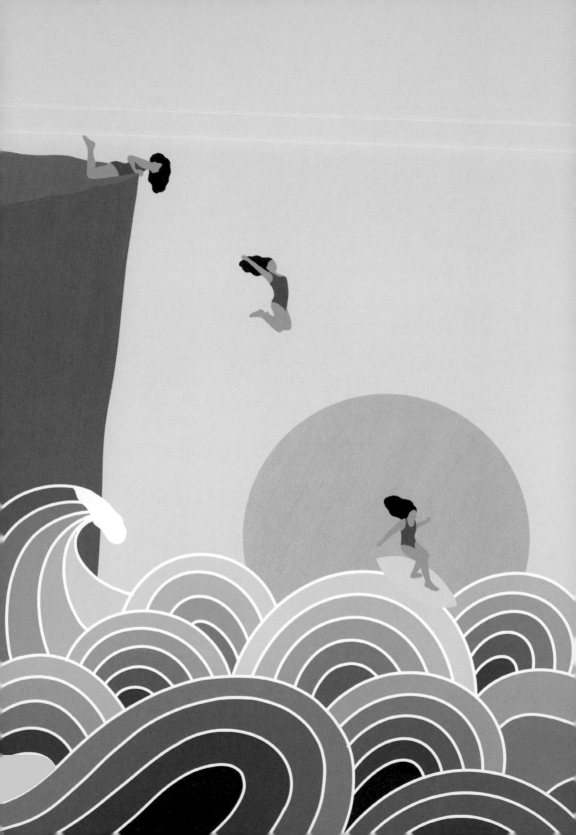

SOMETIMES, IN THE WAVES OF CHANGE
WE FIND OUR TRUE
DIRECTION

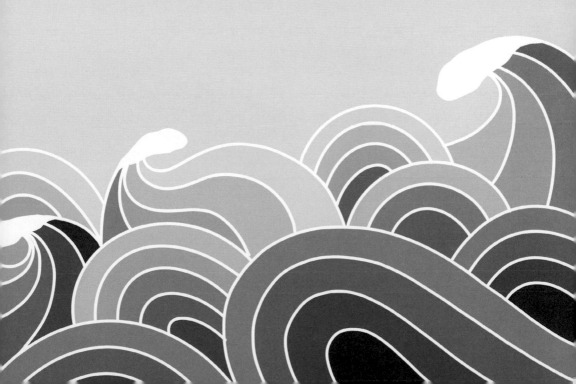

DON'T WORRY IF

YOUR PATH LOOKS DIFFERENT

THERE iS NO STRAiGHT
PATH iN LiFE

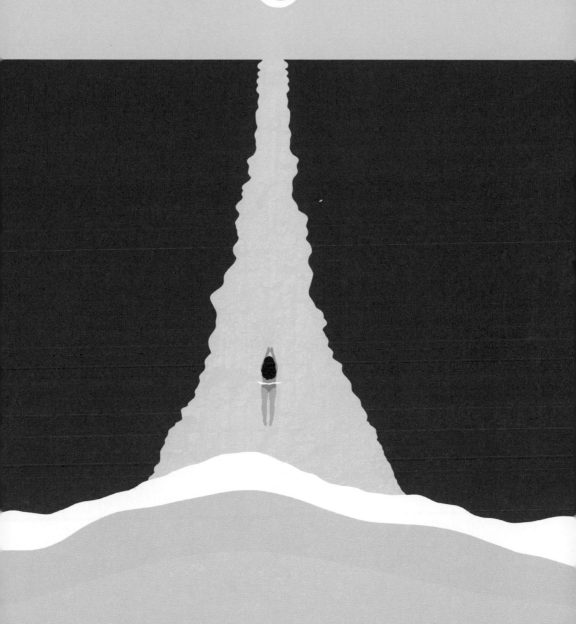

GO YOUR OWN WAY, EVEN IF . . . YOU GO ALONE

PROGRESS
IS NOT
LINEAR

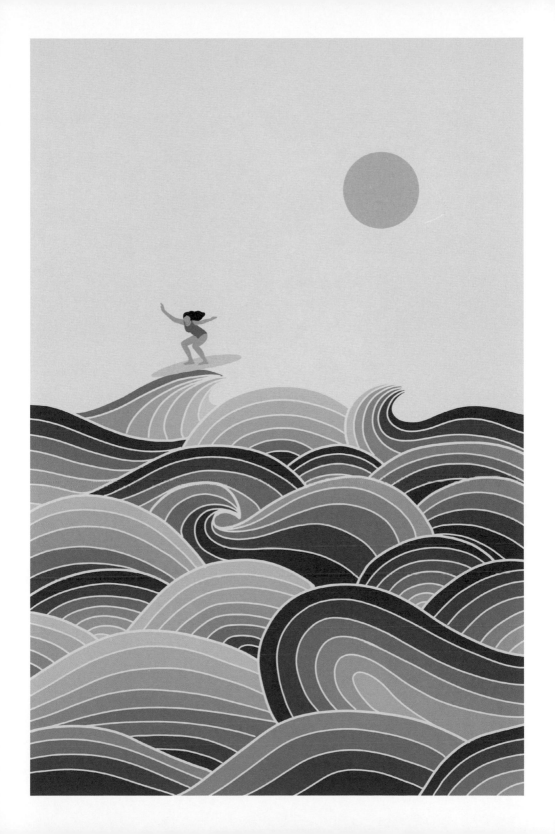

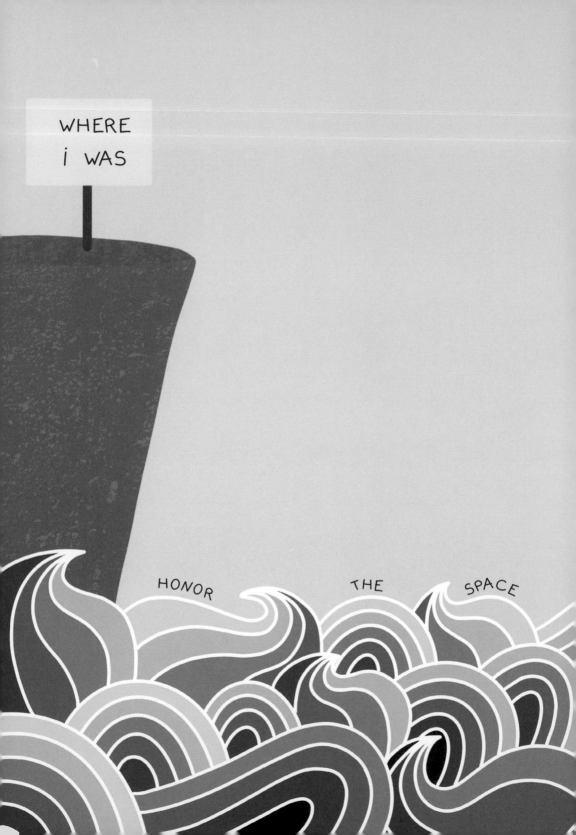

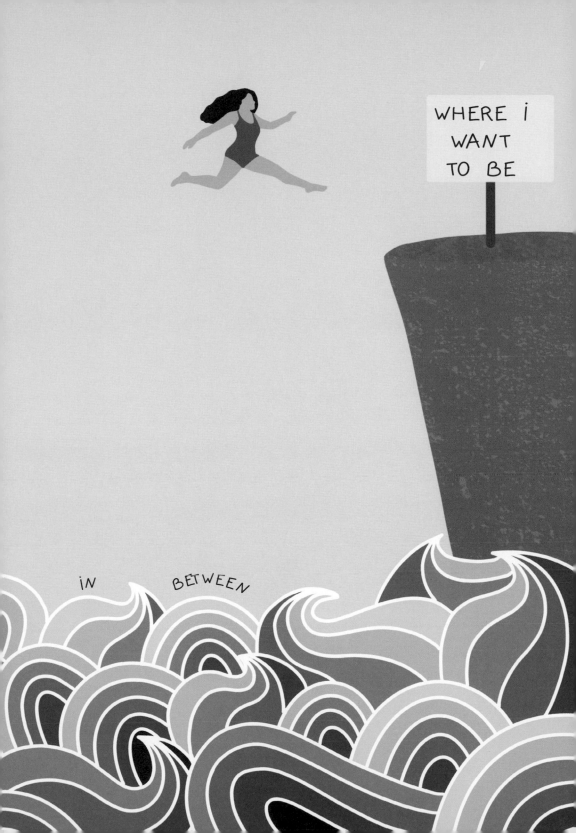

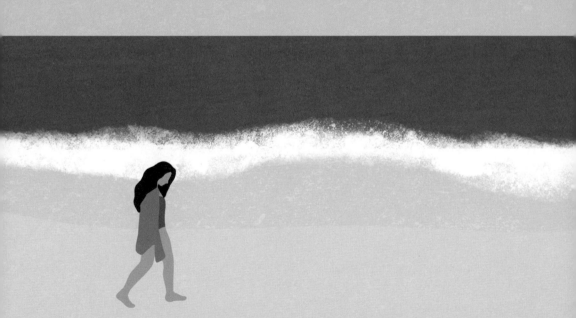

BE THANKFUL FOR THiS MOMENT

THIS MOMENT IS YOUR LIFE

—OMAR KHAYYAM

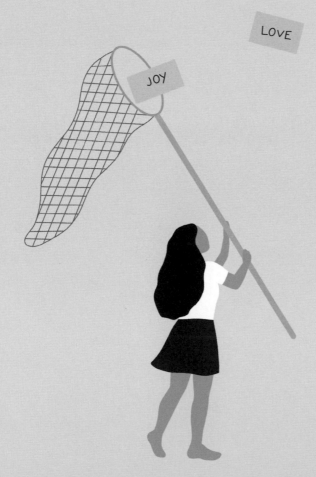

A GRATEFUL HEART IS A MAGNET FOR MIRACLES

WATCHING THE MOON AT DAWN...
I KNEW MYSELF COMPLETELY,
NO PART LEFT OUT

—IZUMI SHIKIBU

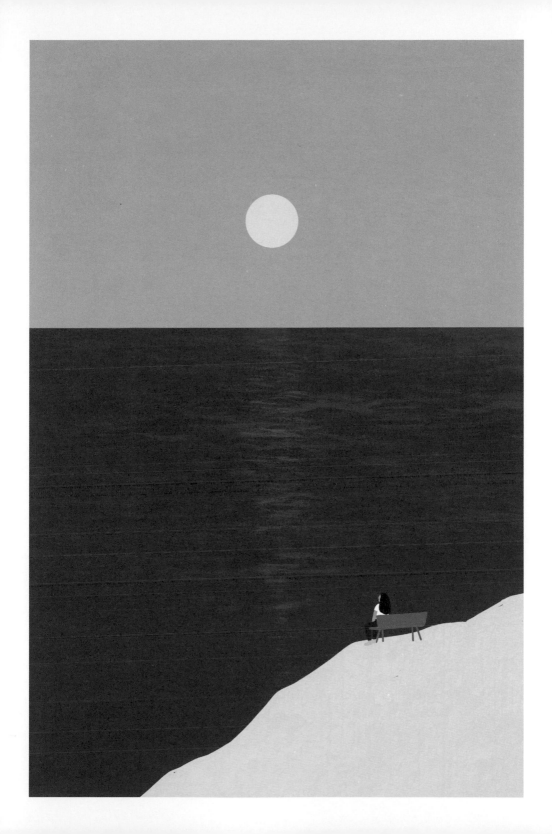

MY BODY IS HOME

TO AN INFINITE UNIVERSE

LET THE WATERS SETTLE
AND YOU WILL SEE

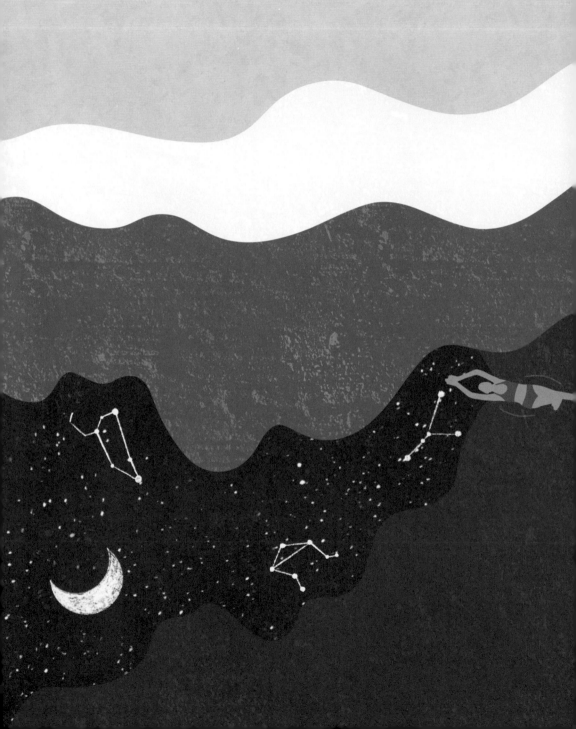

THE MOON AND THE STARS
REFLECTED IN YOUR OWN BEING

—RUMI

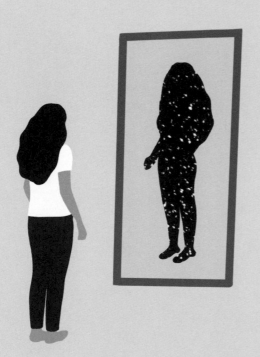
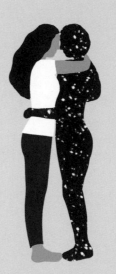

LOVING MYSELF

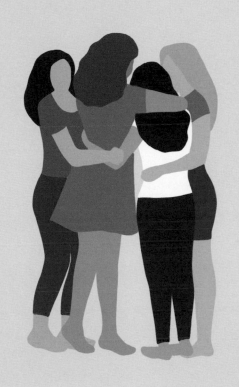

i CAN LOVE OTHERS

KNOWING MYSELF

i AM FREE

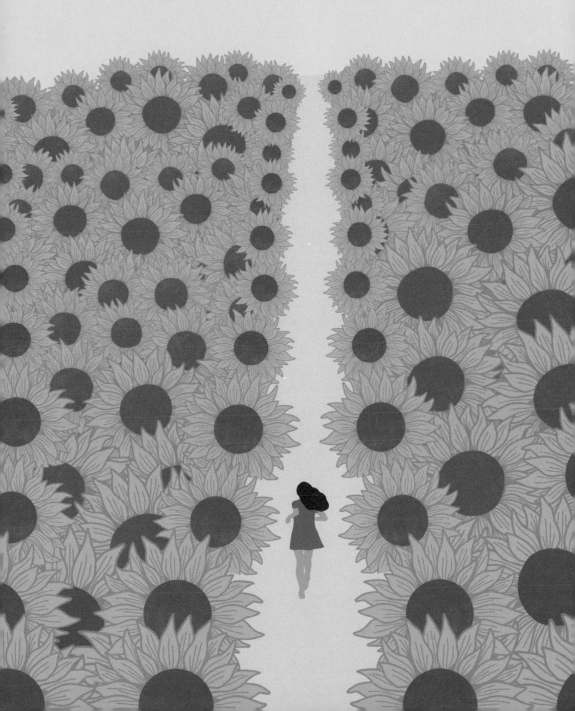

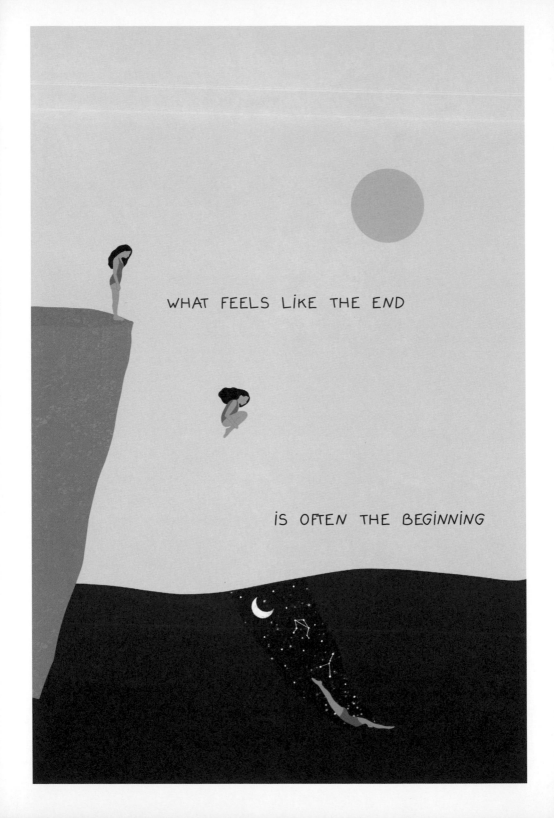

WE STARTED ON THIS JOURNEY TALKING ABOUT
BEGINNINGS, AND HOW THEY CAN OFTEN BE DIFFICULT
AND SCARY. BUT HOW ABOUT ENDINGS?

JUST AS THE START OF SOMETHING NEW CAN QUICKLY
BECOME EXCITING AFTER SEEMING DAUNTING AT FIRST,
I THINK ENDINGS HAVE THEIR BEAUTY TOO. WHEN
WE END A CHAPTER, WE CAN CHOOSE TO HONOR
WHAT IT HAS TAUGHT US BY TAKING ITS LESSONS
AWAY WITH US INTO THE NEXT ONE.

IN THE SAME WAY, I HOPE YOU CLOSE THIS BOOK
WITH A SMILE. THERE IS A LITTLE RAY OF SUNSHINE
HIDDEN IN ITS PAGES. I HOPE YOU TAKE IT WITH YOU
ON THE NEXT PART OF YOUR JOURNEY, KNOWING IT
IS ALWAYS THERE FOR YOU WHENEVER YOU NEED A
LITTLE EXTRA LIGHT.

Library of Congress Control Number: 2022944735

ISBN 978-0-593-58042-4

eISBN 978-0-593-58043-1

Printed in China

Book design by maru studio

Cover design by Robert Diaz

10 9 8 7 6 5 4 3 2 1

First Edition